Advanced Calligraphy

The Art of Beautiful Writing

by

Katherine Jeffares

A Tirzala Powers Publication

Published by

Melvin Powers

Wilshire Book Company
12015 Sherman Road
No. Hollywood, California 91605
telephone: (213) 875-1711

Printed in the United States of America
Library of Congress Catalog Card No.: 79-66662
ISBN: 0-87980-372-X

Dedication

To all my brothers and sisters
at Prana Theological Seminary.
J.R. is right: doing does it.

Thank-you

To three Calligraphers whose
beautiful books on Calligraphy
are so inspiring for those who
want to go beyond beginning
Calligraphy:

Byron Macdonald, _Calligraphy:_
The Art of Lettering with the Broad Pen.

Margaret Shepherd, _Learning Calligraphy_

Jacqueline Svaren, _Written Letters_

And to Dover Publications for their amazing
collection of decorative books.

Table of Contents

Introduction

Materials & Reminders
before you begin

Materials For Advanced Calligraphy

1. Pen Set: The Osmiroid Lettering set with six nib sizes. Number 75 is a better style pen than the old style #65.

2. The Osmiroid Copperplate for fine line drawing.

3. Paper: For lettering which will be reprinted, the tracing pad called Vidalon by Canson #90.
 For lettering on Parchment: Aquabee white or antique yellow Calligraphy Pads, sizes 9"x12", 11"x14" and for large work 14"x17". Also plain bond for practice.

4. Inks: Pelikan Fount India Ink.
 For colored inks remember that many brands have lacquer in the mixture and must be used only with a dip pen or a steel brush. Do not use these inks in the fountain pen as in will destroy the delicate plastic parts.

5. Concentrated Watercolors: For color designs, Luma or P.H. Martin brands can be used in the fountain

(5. cont.) pen. After using wash the pen out with plain alcohol. See the section on Gold Leafing for a solution of water, ammonia and Liquid Detergent for cleaning brushes. That same solution is also great for cleaning clogged up pen nibs.

6. Kneaded erasures are my favorite for cleaning up pencil marks.

7. See-through plastic 12" ruler with a T bar at one end for ruling lines.

8. The Design Art Pen with a chisel point #492 is about the same size as the Osmiroid B4. It comes in a variety of colors.

9. For easier color designs, colored marker pens, such as Pentel makes, are excellent to use.

10. Rags or paper towels for clean up.

11. Small sable brushes for colored inks or watercolors.

12. Optional: the Pelikan Pen Set with three nibs: small, medium and broad.

13. A exacto knife with a sharp point for cleaning up mistakes.

Reminders

1. All three alphabets are written for practice with the Osmiroid B4. Graphs are provided in the last few pages of this textbook for the other size pen nibs.

2. Pen Angle: 45° for simple Blackletter & Bookhand
 30° or flatter angle for Fancy Blackletter

3. Pen Nib Widths:

 a) Small Letters are usually five pen nib widths.
 Four pen nib widths for fatter letters.
 Six pen nib widths for elongated look to letters.

 b) Eight pen nib widths for capitals and tall stem letters.

4. Pen Nib Widths Samples:

Chapter One
Simple Blackletter

Simple Blackletter

abcdefghijklmno

pqrstuvwxyz

ABCDEFGH

IJKLMNOP

QRSTUVW

XYZ

the "i" family

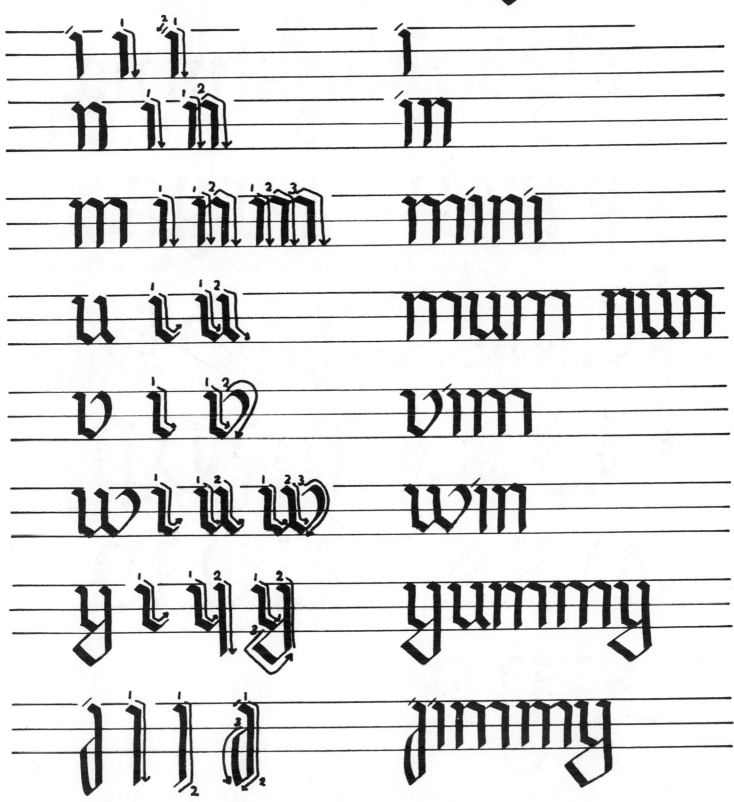

7

the "o" family

o c o yo yo

a c a jam man

g c g g ago gin

d c c d down gad

p r r p pan nap

q c q quad

the "c" family

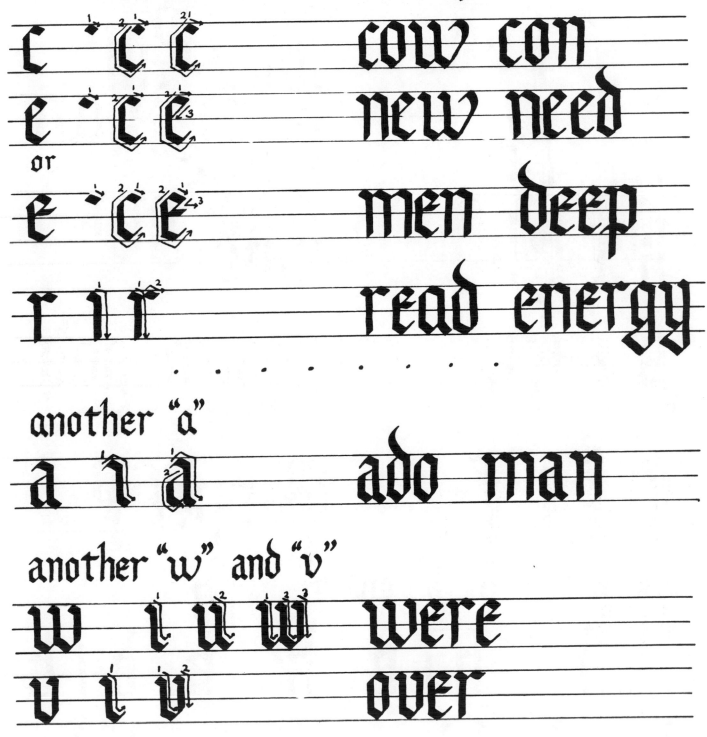

cow con

new need

or

men deep

read energy

another "a"

ado man

another "w" and "v"

were

over

the "l" family

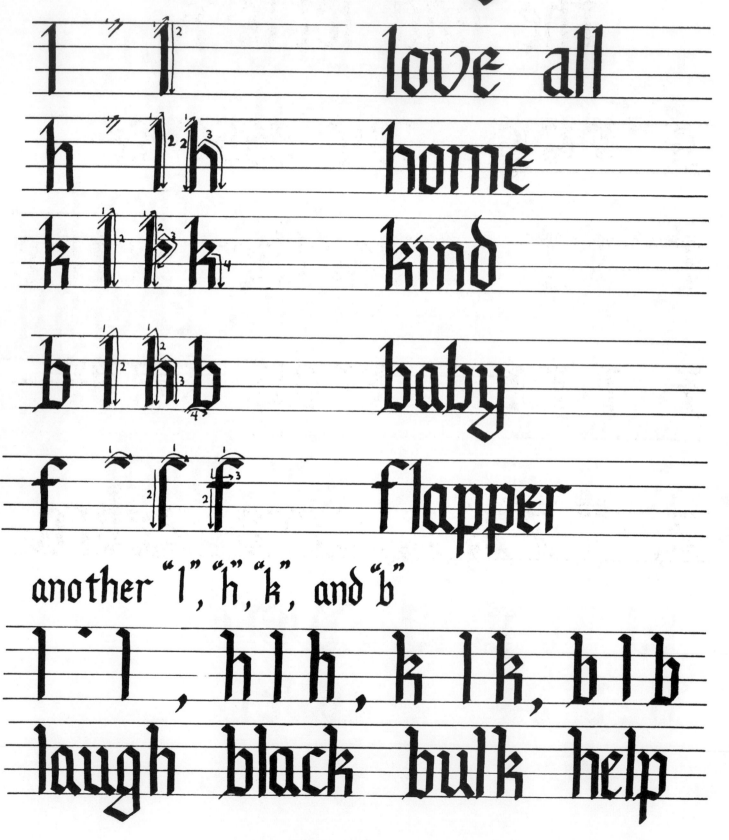

l l l love all

h l h home

k l k kind

b l h b baby

f f f f flapper

another "l", "h", "k", and "b"

l l , h l h , k l k , b l b

laugh black bulk help

10

the odd letters

s sole essence

t together settle

x fray xerox

z zero zebra

The Capitals

A ⁻⁷A A **Alfred**

B I I RB **Billy**

C C C C **Candy**

D I I D **Daniel**

E C C E **Edward**

F ⁻ I I F **Franklyn**

G ~ C G G George

h ~ ll h Herbert

I ~ II I Ivan

J ~ II J Jimmy

K ~ II K Kate

L ~ II L Larry

M ~ M M Mary

N ℓ ∩ N Nancy

O ℓ ℓℓ O Omar

P ℓ ℓ P P Philip

Q ℓ ℓ ℓℓ Q Quince

R ℓ ℓ R Robert

S ̃ ̃ S S S S Sally

T ̃ ̃ T T T Theresa

U C C U U Uncle Tim

V I I V V Victor

W I I V U W William

X I I X X X-ray

Y I I Y Y Yvonne

Z I Z Z Z Zebra

Chapter Two

Fancy Blackletter

fancy
Blackletter

abcdefghijklm

nopqrstuvvw

wxyz

the small letters

Please note: Pen angle is not 45° but slightly flatter.

the "i" family

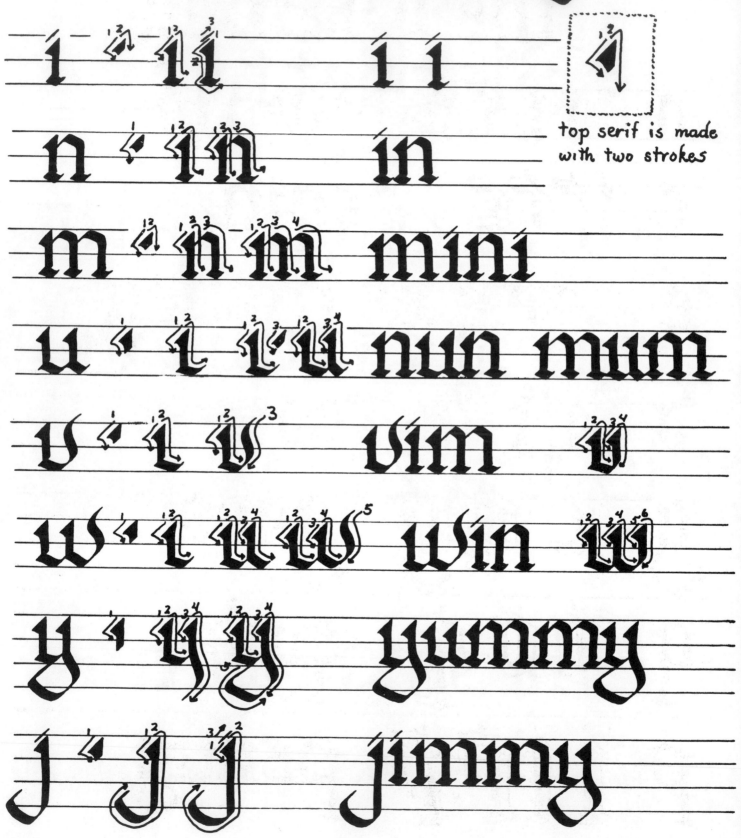

top serif is made with two strokes

18

the "o" family

o "ilco yo yo

c "rc coin

e "ree money

o "icd done

g "i ag good

q "i oq quid

p "lrp penny

19

the "l" family

l l l love will

h l h home hill

b l h b bell

k l r k kill knell

f l l f full fine

20

the odd letters

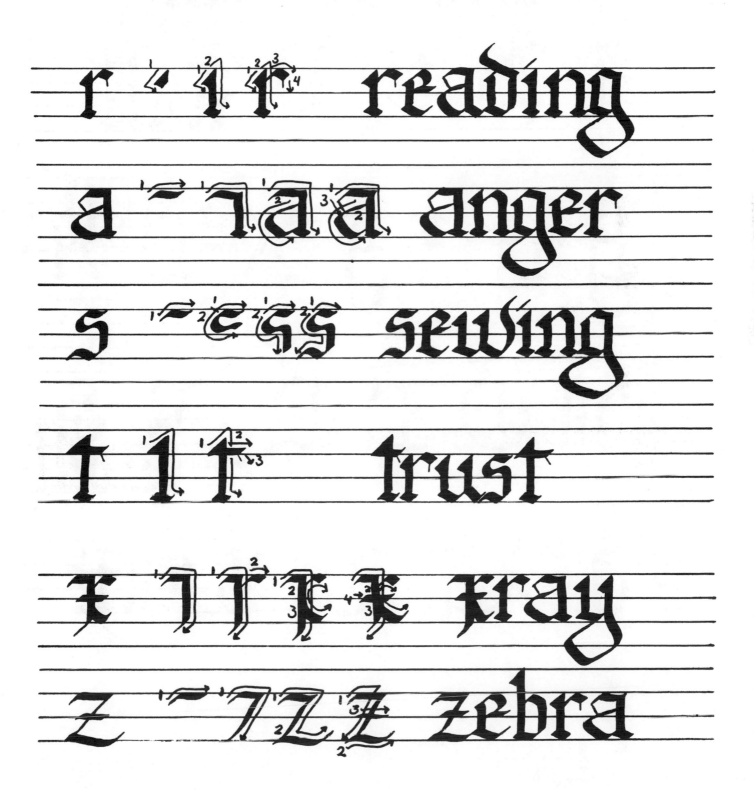

r reading

a anger

s sewing

t trust

x xray

z zebra

the capitals

A B C D E Ff

G H I J K L M

N O P Q R S

T U V W X

Y Z

A ᛁ⁊⁊A Alice

B ⁊⁊⁊B Betty

C C C C C Candace

D D D D D Donald

E C C C E Evie

F ⁊⁊⁊F Frank

G C C C G G George

H ʰ ʃ H H Helen

I ʰ ʃ I I I Irene

J ʰ ʃ J J J James

K K Y K Kathy

L L ʃ L L L Louise

M M M M M Mark

N N N N N Nena

O C C O Olivia

P P P P P Patty

Q C C O Queenie

R P P R Roy

S S S S Susan

T C C T Thomas

U U U Urchin

V V V V V Vickie

W W W W Walter

X X X X X Xylophone

Y Y Y Y Y Ynez

Z Z Z Z Zoomer

• • • •

more capitals

A B C D E F G

H I J K L M N

O P Q R S T

U V W X Y Z

Someone celebrating their wedding feast asked me to make table decorations using the word "Love" in different languages. I chose Blackletter Capitals.

LOVE
English

LUVE
Middle English

LIEBE
German

EROS
Greek

AMOUR
French

LUIBOU
Russian

אהבה/חב,ה
Hebrew

AI or
Japanese

KÄRLEK - Swedish

Chapter Three

Humanistic Bookhand

also called

Foundation

The Alphabet

a a b c d e f g h i j
k l m n o p q r s t
u v w x y z

A B C D E F G H I
J K L M N O P Q
R S T U V W X Y
Z

"i" family

i ii ii ii

n in in in

m inm mini mini

u iu nun

j jj jimmy

r ir ruin

"i" family cont.

v v i v vim

w w ii u w win

y y i y yummy

"o" family

c c̃ c̃ cry

e ẽ c̃e rye men

o ꜱo o coin omen

d d̃ c̃d dry done

p p p penny

q c̃ q quip

g ꜱꜱg g give

"l" family

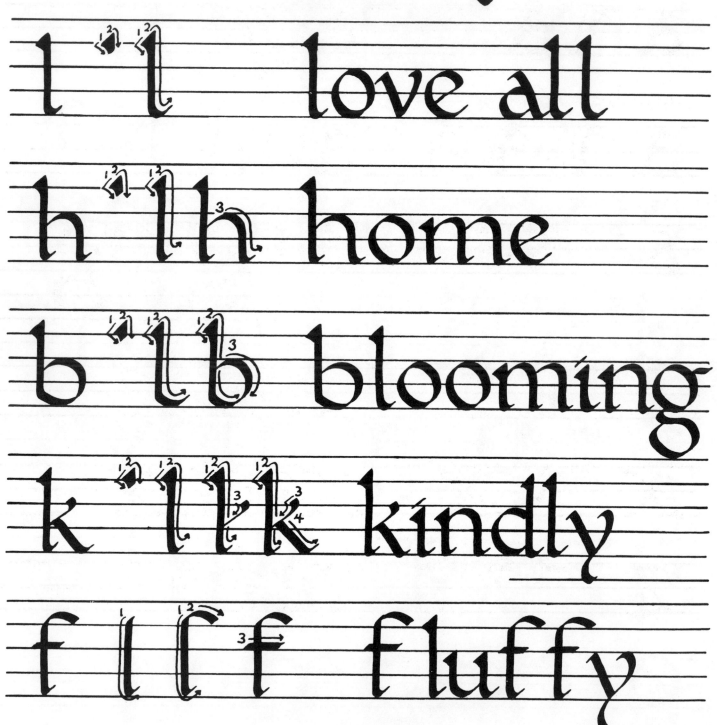

l l l love all

h l h home

b l b blooming

k l l k kindly

f l l f fluffy

34

odd letters

a ìa ìa ago

another "a"

a ìa ìa ìa aim

s ˢ ˢ ˢ ˢ singing

t t t t trade

x x x x xerox

z z z z zero

35

The Capitals

A ／＼/＼ Adam

B |P B Blayne

C ⌒C Candy

D |D Doris

E |ΓE Edith

F |ΓF Frank

G G CG G George

H H H H H Harriet

I Izzie

J J J Joseph

K K K K Kenneth

L L L Lennie

M M M M Mason

37

N 1 1 N N Nicholas

O C O O Oliver

P 1 P Peter

Q COQ Quentin

R 1 P R Roanne

S S S S Steven

T T T Timmie

U U U U Ursula

V V V V Victoria

W W W W Wendell

X X X X Xavier

Y Y Y Y Yolanda

Z Z Z Zachary

Chapter Four

Gold Leafing
&
Other Decorative
Devices

Materials For Gold Leafing

1. Packages of sheets of gold leaf – also called Dutch Metal. There are 20 sheets in one package. This is a mixture of gold with Aluminum alloys. Pure gold can also be bought in sheets but is far more expensive.

2. Adhesive sizing, plain or Venetian Red (a color which can be added to the sizing creating a red background for the Gold). "Old World" is a well known brand.

3. Camel Hair or Sable Brushes sizes "00", "0" and "1" in size for small designing.

4. A large Camel Hair brush, size $\frac{3}{4}$ of an inch, for cleaning up excess gold.

5. Gold Leaf Burnisher.

6. Large envelope for cleaning up excess gold.

7. Solution for cleaning brushes: in an empty glass jar mix 8 oz. of water, a teaspoon of ammonia, and a teaspoon of liquid detergent. Put cover on jar.

Materials (cont.)

8. A ruling pen set for making thin border lines.
9. Ruler you can see thru for use with the ruling pen.
10. Variety of pencils with a hard point ~ the "H" series.
11. Parchment paper ~ white or antique, any size.
12. Exacto-Knife for scraping off mistakes.

Friendship is a chain of gold
Shaped in God's all perfect mold;
Each link a smile, a laugh, a tear,
A touch of the hand, a word
of cheer.

The above quote by Frank Sherman was designed
with a gold leafed border by Kathleen Murphy

The Gold Leafing Process:
also known as Illumination

1. Set out the equipment to be used. Work on a flat hard surface. Do not use a slanted table or board.

2. Mark with a hard lead pencil the area to be gold-leafed. Erase the pencil lead lightly with a kneaded erasure so that the pencil lines faintly show.

3. Put a small amount of liquid adhesive sizing in area laid out in pencil lines. A variety of tools can be used here: small watercolor brushes for backgrounds and designs, a dip pen for letters, and a ruling pen for lines. Place the sizing in smooth strokes making sure it does not puddle as this increases drying time.

4. Let the liquid adhesive dry for about 1 hour and when it is set but still tacky place the gold leaf or a part of it on top of the sizing.

Illumination cont.

5. In cutting out the piece of gold leaf do not breath heavily on it or it will fly away. Also make sure your fingers are not sticky with the adhesive sizing as the gold will cling to your fingers and not come off.

6. Use a sharp scissors and cut both the gold and a piece of the paper under it in the booklet. Also by carefully tearing the gold leaf with your fingers eliminates the need for scissors.

7. Make sure the gold to be adhered is slightly larger than the area painted with sizing.

8. Next place the gold on top of the sizing; watch that you don't breath heavily on it. Press the gold with your fingers to make sure it is in place. Use the thin sheet of paper between the gold and your fingers. Lift the paper and if it sticks anywhere put more gold-leaf in that spot.

9. Lay the thin sheet of paper back on top of the gold and burnish it or rub it with the burnisher.

Illumination cont.

10. The burnisher point may be used on a double layer of gold to angle the sides. The second layer can be added on after burnishing the first layer. Follow the exact same steps as above.

11. Finally with the burnishing completed, remove the thin sheet of paper that you use for burnishing and with a soft bristled brush dust off the bits of remaining gold into a waste basket. Larger pieces can be put into a large envelope for future use.

12. Clean your small brushes that you used to put on the sizing with the cleaning solution listed as number 7 in materials for gold-leafing.

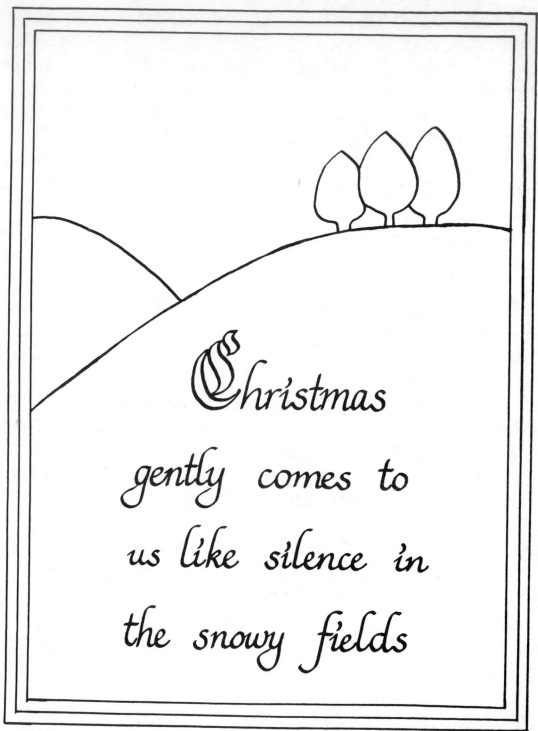

Christmas
gently comes to
us like silence in
the snowy fields

This Christmas card was designed by
Kathleen Murphy. She painted the scene in
soft muted colors and illuminated the "C" of
Christmas in gold leaf.

46

Rubrication

Another process commonly used to decorate the very first letter by painting or inking it in the color red is called rubrication. This process is often used in Bibles, hymnals and spiritual books today using a red printer's ink.

In decorating a calligraphic work red can best be utilized from the bright pigments of concentrated red watercolor or a bright red ink made with lacquer to be lettered with a dip pen.

Often a beautiful letter can be made by outlining it in red and filling it in with gold-leafing, or doing the entire letter in red and a flower design around it in gold.

Foliated Capitals

The easiest way to decorate a Capital letter is with leaf and simple flower designs,

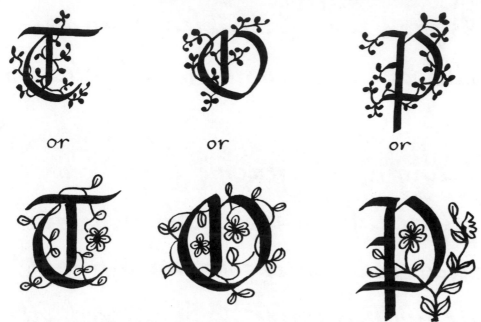

or or or

and many, many other ways.

Textured Capitals

Another way is to decorate with dots, squares, diamonds, checker-board, stripes and O-Gees.

Stipling with dots

Squares in plaids

Diamonds Checker-board

Using many colors makes the designs stand out.

Textured Capitals (cont.)

Stripes & O-Gee designs

Inhabited Capitals

Historiated Capitals

Bible Stories are most commonly used

A man should never be ashamed to own he has been in the wrong, which is but saying, in other words, that he is wiser today than he was yesterday.

Alexander Pope

Calligraphy by Donna Zappa

Chapter Five
Ideas for Design
&
Layout

My appreciation and thanks to my students at Prana Theological Seminary and University Community Adult School for their assistance in creating this chapter. Most of them had only nine or ten lessons before lettering their designs, proving that almost anyone can do Calligraphy.

A majority of the works are in Chancery Cursive and Adam Christensen's Bookhand.

A special thanks to Kathleen Murphy for the additional samples in Old English, Blackletter and Foundational Bookhand.

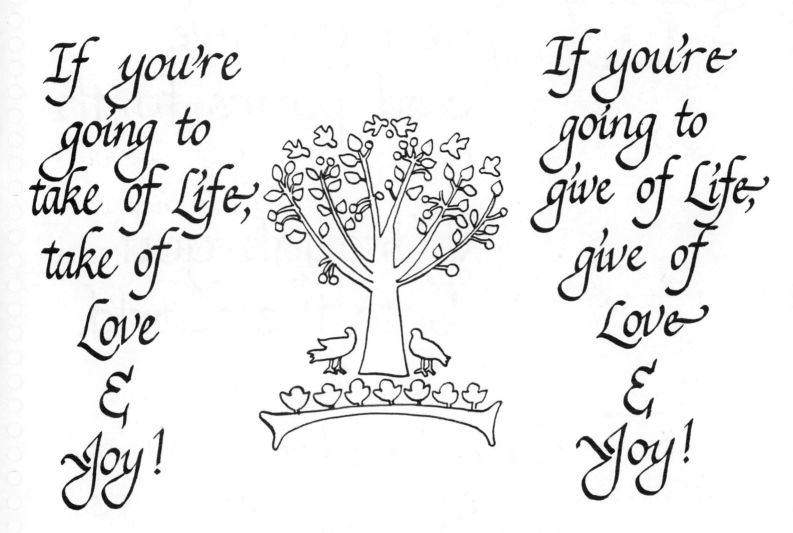

If you're going to take of Life, take of Love & Joy!

If you're going to give of Life, give of Love & Joy!

calligraphy by Vicki Lacher

The next five pages are taken from the writings of John-Roger by my calligraphy students at Prana.

when you love .
you live .

W hen you live
God pours forth
His energies
Through you
Into the world.

• • • • • • •

The Christ
within you
knows the
Christ in
Others

from the writings of John-Roger
calligraphy by Debbie Morris

54

Prayer is our talking to God.

Meditation is our listening for the answer.

Contemplation is looking at the path to God.

Spiritual exercises is walking the path to God.

John-Roger

The above design was created by Debbie Morris in a Bookhand style developed by Adam Christensen.... See my first textbook: Calligraphy: The Art of Beautiful Writing.

Resolve yourself
to Light and Love
and worship the
God that remains
nameless.

John-Roger

calligraphy by Susan Huntzinger

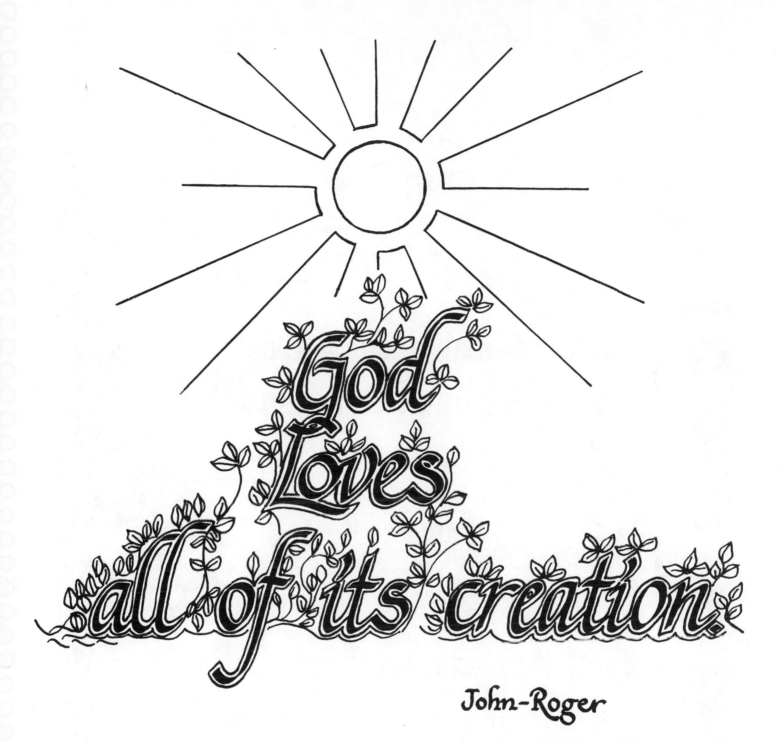

God Loves all of its creation.

John-Roger

This design above was created by Bruce Rathbun using the Ozmiroid B4, outlining the letters with the Pelikan Fine Nib. The Ozmiroid Copperplate created the leaves.

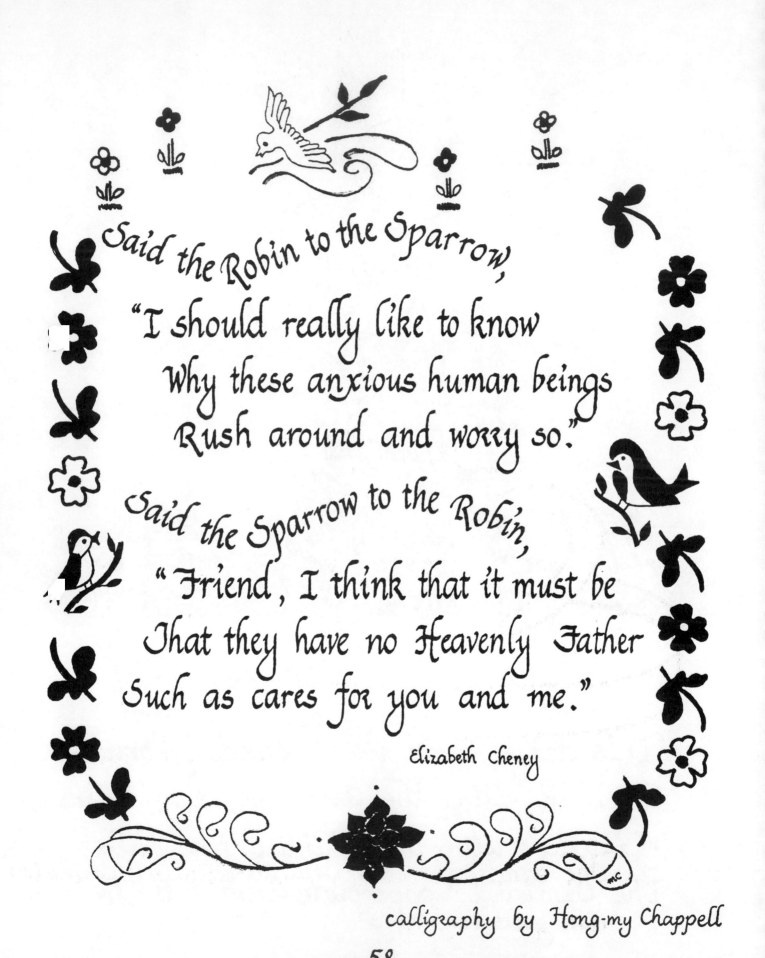

Said the Robin to the Sparrow,
"I should really like to know
Why these anxious human beings
Rush around and worry so."

Said the Sparrow to the Robin,
"Friend, I think that it must be
That they have no Heavenly Father
Such as cares for you and me."

Elizabeth Cheney

calligraphy by Hong-my Chappell

58

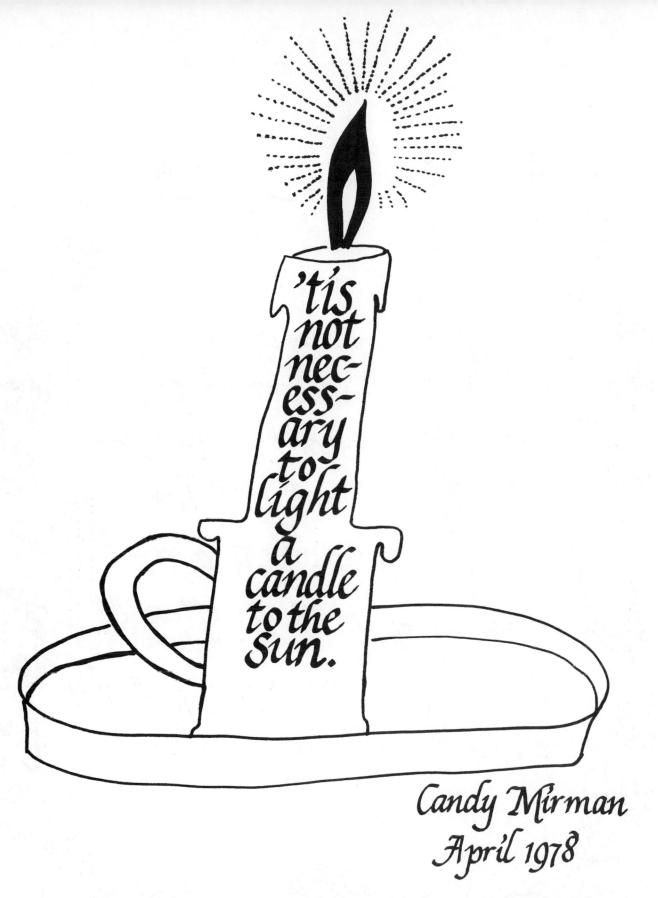

'tis not necessary to light a candle to the sun.

Candy Mirman
April 1978

The candle flame of orange-red was "illuminated" with gold-leaf dots.

t is good sense in a man to be slow to anger, and it is his glory to over-look an offense.

Proverbs 19:11

calligraphy by Doris Fisher

Smile for the
joy of others.

Calligraphy by Doris Fisher; design from
a collection of Early American Art by Dover.

Merry Christmas
and
Happy New Year

Donna Arand

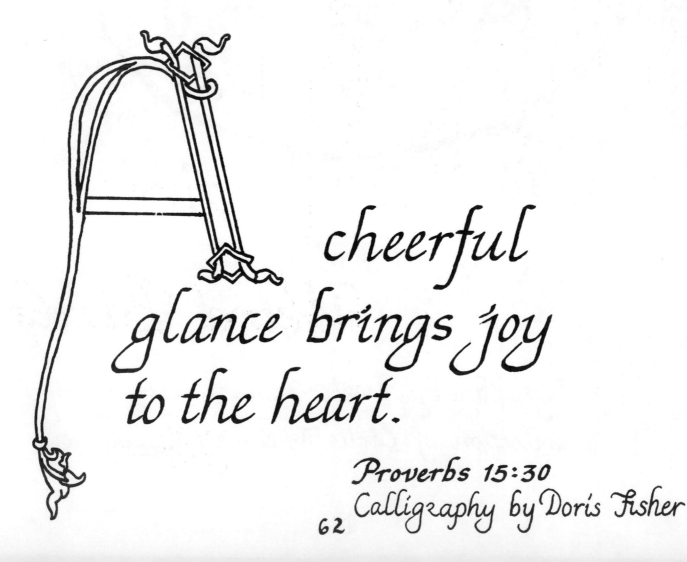

A cheerful glance brings joy to the heart.

Proverbs 15:30
Calligraphy by Doris Fisher

62

Flighty

People

Are

Weird Birds

J. Lemer

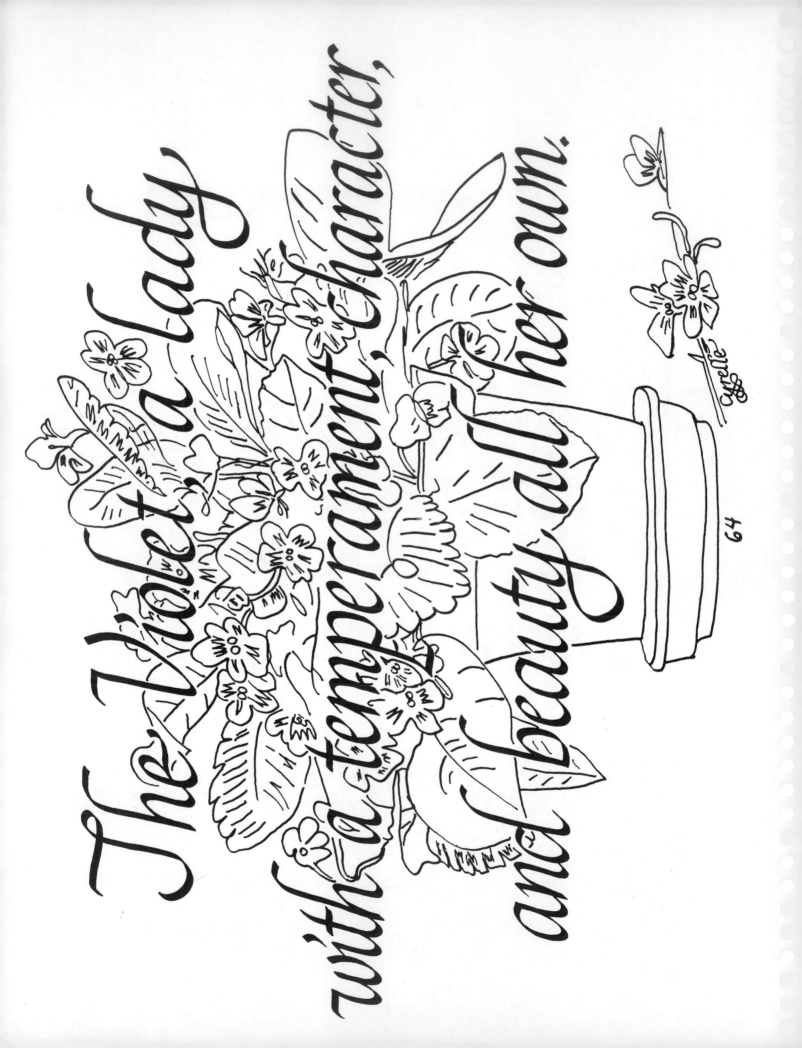

The Violet, a lady
with a temperament, character,
and beauty all her own.

64

Jack be nimble,
Jack be quick,
Jack jump
over the
Candlestick.

calligraphy by Kathleen Murphy

65

Ah make the most of what
we yet may spend,
Before we too in dust descend;
dust into dust,
And under to lie; sans wine,
sans song, singer, end!

by Omar Khayam

- -

Old English Calligraphy by Kathleen Murphy

It is hard to
Find a man who will
Study for three
Years without thinking
Of a post in
Government!

Confucius

Blackletter Calligraphy by Kathleen Murphy

Worthiness

It is my joy in life to find at every turning of the road strong arms of a comrade kind to help me onward with my load; and since I have no gold to give, and love alone must make amends, my prayer is, while I live — God make me worthy of my friends.

Frank Sherman

Foundational Bookhand by Kathleen Murphy

One Set of Footprints...

One night a man had a dream. He dreamed he was walking along the beach with the Lord. Across the sky flashed scenes from his life. For each scene he noticed two sets of footprints in the sand ~ one belonging to him and the other belonging to the Lord. When the last scene had flashed before him, he looked back at the footprints and noticed that many times along the path there was only one set of footprints in the sand. He also noticed that this happened during the lowest and saddest times in his life.

This really bothered him and he questioned the Lord, "Lord, you said that once I decided to follow you, you would walk all the way, but I noticed that during the most troublesome times of my life there was only one set of footprints. I don't understand why, when I needed you most, you deserted me."

The Lord replied, "My precious child, I love you and would never leave you. During your times of trial and suffering, when you see only one set of footprints, it was then that I carried you." (copied)

calligraphy by
Hong-my Chappell.

69

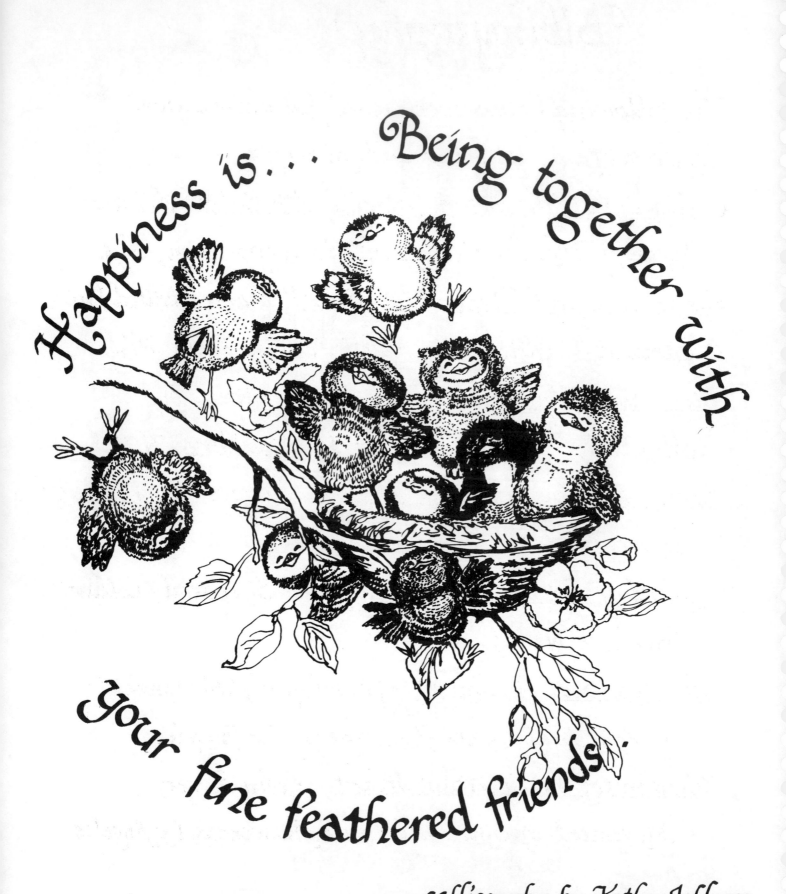

Happiness is . . . Being together with your fine feathered friends

calligraphy by Kathy Jeffares

Bibliography

The following books were used for assistance in decoration, lettering and poetry.

Calligraphy: The Art of Lettering with the Broad Pen, Byron J. Macdonald, Pentalic Corporation, N.Y.

Cartouches and Decorative Small Frames, edited by Edmund V. Gillon, Jr., Dover Publications, N.Y.

Decorative Alphabets and Initials, edited by Alexander Nesbitt, Dover Publications, N.Y.

Early American Design Motifs, Suzanne E. Chapman, Dover Publications, New York.

Learning Calligraphy, Margaret Shepherd, Collier Books, New York.

The Spiritual Promise, John-Roger, Movement of Spiritual Inner Awareness, Los Angeles.

Wisdoms of the Spiritual Heart, John-Roger, Movement of Spiritual Inner Awareness, Los Angeles.

(cont. next page)

Bibliography (cont.)

Writing & Illuminating & Lettering, Edward Johnson, Pentalic Corporation, New York.

Written Letters: 22 Alphabets For Calligraphers, Jacqueline Svaren, Bond Wheelwright, Freeport, Maine.

&

my own book...

Calligraphy: The Art of Beautiful Writing, Katherine Jeffares, Wilshire Book Company, North Hollywood, California.

A fine nib of
Osmiroid

for broad
Osmiroid

for B2
osmiroid

for B3 nib
of Osmiroid

B4 nib of
Osmiroid

A Personal Word From Melvin Powers
Publisher, Wilshire Book Company

Dear Friend:

My goal is to publish interesting, informative, and inspirational books. You can help me accomplish this by answering the following questions, either by phone or by mail. Or, if convenient for you, I would welcome the opportunity to visit with you in my office and hear your comments in person.

Did you enjoy reading this book? Why?

Would you enjoy reading another similar book?

What idea in the book impressed you the most?

If applicable to your situation, have you incorporated this idea in your daily life?

Is there a chapter that could serve as a theme for an entire book? Please explain.

If you have an idea for a book, I would welcome discussing it with you. If you already have one in progress, write or call me concerning possible publication. I can be reached at (213) 875-1711 or (213) 983-1105.

Sincerely yours,

Melvin Powers

12015 Sherman Road
North Hollywood, California 91605

MELVIN POWERS SELF-IMPROVEMENT LIBRARY

ASTROLOGY

_____ASTROLOGY: HOW TO CHART YOUR HOROSCOPE *Max Heindel*	3.00
_____ASTROLOGY: YOUR PERSONAL SUN-SIGN GUIDE *Beatrice Ryder*	3.00
_____ASTROLOGY FOR EVERYDAY LIVING *Janet Harris*	2.00
_____ASTROLOGY MADE EASY *Astarte*	3.00
_____ASTROLOGY MADE PRACTICAL *Alexandra Kayhle*	3.00
_____ASTROLOGY, ROMANCE, YOU AND THE STARS *Anthony Norvell*	4.00
_____MY WORLD OF ASTROLOGY *Sydney Omarr*	5.00
_____THOUGHT DIAL *Sydney Omarr*	4.00
_____WHAT THE STARS REVEAL ABOUT THE MEN IN YOUR LIFE *Thelma White*	3.00

BRIDGE

_____BRIDGE BIDDING MADE EASY *Edwin B. Kantar*	5.00
_____BRIDGE CONVENTIONS *Edwin B. Kantar*	5.00
_____BRIDGE HUMOR *Edwin B. Kantar*	3.00
_____COMPETITIVE BIDDING IN MODERN BRIDGE *Edgar Kaplan*	4.00
_____DEFENSIVE BRIDGE PLAY COMPLETE *Edwin B. Kantar*	10.00
_____HOW TO IMPROVE YOUR BRIDGE *Alfred Sheinwold*	3.00
_____IMPROVING YOUR BIDDING SKILLS *Edwin B. Kantar*	4.00
_____INTRODUCTION TO DEFENDER'S PLAY *Edwin B. Kantar*	3.00
_____SHORT CUT TO WINNING BRIDGE *Alfred Sheinwold*	3.00
_____TEST YOUR BRIDGE PLAY *Edwin B. Kantar*	3.00
_____WINNING DECLARER PLAY *Dorothy Hayden Truscott*	4.00

BUSINESS, STUDY & REFERENCE

_____CONVERSATION MADE EASY *Elliot Russell*	2.00
_____EXAM SECRET *Dennis B. Jackson*	3.00
_____FIX-IT BOOK *Arthur Symons*	2.00
_____HOW TO DEVELOP A BETTER SPEAKING VOICE *M. Hellier*	3.00
_____HOW TO MAKE A FORTUNE IN REAL ESTATE *Albert Winnikoff*	4.00
_____INCREASE YOUR LEARNING POWER *Geoffrey A. Dudley*	2.00
_____MAGIC OF NUMBERS *Robert Tocquet*	2.00
_____PRACTICAL GUIDE TO BETTER CONCENTRATION *Melvin Powers*	3.00
_____PRACTICAL GUIDE TO PUBLIC SPEAKING *Maurice Forley*	3.00
_____7 DAYS TO FASTER READING *William S. Schaill*	3.00
_____SONGWRITERS RHYMING DICTIONARY *Jane Shaw Whitfield*	5.00
_____SPELLING MADE EASY *Lester D. Basch & Dr. Milton Finkelstein*	2.00
_____STUDENT'S GUIDE TO BETTER GRADES *J. A. Rickard*	3.00
_____TEST YOURSELF—Find Your Hidden Talent *Jack Shafer*	3.00
YOUR WILL & WHAT TO DO ABOUT IT *Attorney Samuel G. Kling*	3.00

CALLIGRAPHY

_____ADVANCED CALLIGRAPHY *Katherine Jeffares*	7.00
_____CALLIGRAPHER'S REFERENCE BOOK *Anne Leptich & Jacque Evans*	6.00
_____CALLIGRAPHY—The Art of Beautiful Writing *Katherine Jeffares*	7.00
_____CALLIGRAPHY FOR FUN & PROFIT *Anne Leptich & Jacque Evans*	7.00
_____CALLIGRAPHY MADE EASY *Tina Serafini*	7.00

CHESS & CHECKERS

_____BEGINNER'S GUIDE TO WINNING CHESS *Fred Reinfeld*	3.00
_____BETTER CHESS—How to Play *Fred Reinfeld*	2.00
_____CHECKERS MADE EASY *Tom Wiswell*	2.00
_____CHESS IN TEN EASY LESSONS *Larry Evans*	3.00
_____CHESS MADE EASY *Milton L. Hanauer*	3.00
_____CHESS PROBLEMS FOR BEGINNERS *edited by Fred Reinfeld*	2.00
_____CHESS SECRETS REVEALED *Fred Reinfeld*	2.00
_____CHESS STRATEGY—An Expert's Guide *Fred Reinfeld*	2.00
_____CHESS TACTICS FOR BEGINNERS *edited by Fred Reinfeld*	3.00
_____CHESS THEORY & PRACTICE *Morry & Mitchell*	2.00
_____HOW TO WIN AT CHECKERS *Fred Reinfeld*	3.00
_____1001 BRILLIANT WAYS TO CHECKMATE *Fred Reinfeld*	4.00
_____1001 WINNING CHESS SACRIFICES & COMBINATIONS *Fred Reinfeld*	4.00
_____SOVIET CHESS *Edited by R. G. Wade*	3.00

COOKERY & HERBS

_____CULPEPER'S HERBAL REMEDIES *Dr. Nicholas Culpeper* 3.00
_____FAST GOURMET COOKBOOK *Poppy Cannon* 2.50
_____GINSENG The Myth & The Truth *Joseph P. Hou* 3.00
_____HEALING POWER OF HERBS *May Bethel* 3.00
_____HEALING POWER OF NATURAL FOODS *May Bethel* 3.00
_____HERB HANDBOOK *Dawn MacLeod* 3.00
_____HERBS FOR COOKING AND HEALING *Dr. Donald Law* 2.00
_____HERBS FOR HEALTH—How to Grow & Use Them *Louise Evans Doole* 3.00
_____HOME GARDEN COOKBOOK—Delicious Natural Food Recipes *Ken Kraft* 3.00
_____MEDICAL HERBALIST *edited by Dr. J. R. Yemm* 3.00
_____NATURAL FOOD COOKBOOK *Dr. Harry C. Bond* 3.00
_____NATURE'S MEDICINES *Richard Lucas* 3.00
_____VEGETABLE GARDENING FOR BEGINNERS *Hugh Wiberg* 2.00
_____VEGETABLES FOR TODAY'S GARDENS *R. Milton Carleton* 2.00
_____VEGETARIAN COOKERY *Janet Walker* 4.00
_____VEGETARIAN COOKING MADE EASY & DELECTABLE *Veronica Vezza* 3.00
_____VEGETARIAN DELIGHTS—A Happy Cookbook for Health *K. R. Mehta* 2.00
_____VEGETARIAN GOURMET COOKBOOK *Joyce McKinnel* 3.00

GAMBLING & POKER

_____ADVANCED POKER STRATEGY & WINNING PLAY *A. D. Livingston* 3.00
_____HOW NOT TO LOSE AT POKER *Jeffrey Lloyd Castle* 3.00
_____HOW TO WIN AT DICE GAMES *Skip Frey* 3.00
_____HOW TO WIN AT POKER *Terence Reese & Anthony T. Watkins* 3.00
_____SECRETS OF WINNING POKER *George S. Coffin* 3.00
_____WINNING AT CRAPS *Dr. Lloyd T. Commins* 3.00
_____WINNING AT GIN *Chester Wander & Cy Rice* 3.00
_____WINNING AT POKER—An Expert's Guide *John Archer* 3.00
_____WINNING AT 21—An Expert's Guide *John Archer* 4.00
_____WINNING POKER SYSTEMS *Norman Zadeh* 3.00

HEALTH

_____BEE POLLEN *Lynda Lyngheim & Jack Scagnetti* 3.00
_____DR. LINDNER'S SPECIAL WEIGHT CONTROL METHOD *P. G. Lindner, M.D.* 1.50
_____HELP YOURSELF TO BETTER SIGHT *Margaret Darst Corbett* 3.00
_____HOW TO IMPROVE YOUR VISION *Dr. Robert A. Kraskin* 3.00
_____HOW YOU CAN STOP SMOKING PERMANENTLY *Ernest Caldwell* 3.00
_____MIND OVER PLATTER *Peter G. Lindner, M.D.* 3.00
_____NATURE'S WAY TO NUTRITION & VIBRANT HEALTH *Robert J. Scrutton* 3.00
_____NEW CARBOHYDRATE DIET COUNTER *Patti Lopez-Pereira* 1.50
_____QUICK & EASY EXERCISES FOR FACIAL BEAUTY *Judy Smith-deal* 2.00
_____QUICK & EASY EXERCISES FOR FIGURE BEAUTY *Judy Smith-deal* 2.00
_____REFLEXOLOGY *Dr. Maybelle Segal* 3.00
_____REFLEXOLOGY FOR GOOD HEALTH *Anna Kaye & Don C. Matchan* 3.00
_____YOU CAN LEARN TO RELAX *Dr. Samuel Gutwirth* 3.00
_____YOUR ALLERGY—What To Do About It *Allan Knight, M.D.* 3.00

HOBBIES

_____BEACHCOMBING FOR BEGINNERS *Norman Hickin* 2.00
_____BLACKSTONE'S MODERN CARD TRICKS *Harry Blackstone* 3.00
_____BLACKSTONE'S SECRETS OF MAGIC *Harry Blackstone* 3.00
_____COIN COLLECTING FOR BEGINNERS *Burton Hobson & Fred Reinfeld* 3.00
_____ENTERTAINING WITH ESP *Tony 'Doc' Shiels* 2.00
_____400 FASCINATING MAGIC TRICKS YOU CAN DO *Howard Thurston* 3.00
_____HOW I TURN JUNK INTO FUN AND PROFIT *Sari* 3.00
_____HOW TO PLAY THE HARMONICA FOR FUN & PROFIT *Hal Leighton* 3.00
_____HOW TO WRITE A HIT SONG & SELL IT *Tommy Boyce* 7.00
_____JUGGLING MADE EASY *Rudolf Dittrich* 2.00
_____MAGIC MADE EASY *Byron Wels* 2.00
_____STAMP COLLECTING FOR BEGINNERS *Burton Hobson* 2.00

HORSE PLAYERS' WINNING GUIDES

_____BETTING HORSES TO WIN *Les Conklin* 3.00
_____ELIMINATE THE LOSERS *Bob McKnight* 3.00

_____HOW TO RAISE AN EMOTIONALLY HEALTHY, HAPPY CHILD _A. Ellis_ — 3.00
_____IMPOTENCE & FRIGIDITY _Edwin W. Hirsch, M.D._ — 3.00
_____SEX WITHOUT GUILT _Albert Ellis, Ph.D._ — 3.00
_____SEXUALLY ADEQUATE MALE _Frank S. Caprio, M.D._ — 3.00

MELVIN POWERS' MAIL ORDER LIBRARY
_____HOW TO GET RICH IN MAIL ORDER _Melvin Powers_ — 10.00
_____HOW TO WRITE A GOOD ADVERTISEMENT _Victor O. Schwab_ — 15.00
_____WORLD WIDE MAIL ORDER SHOPPER'S GUIDE _Eugene V. Moller_ — 5.00

METAPHYSICS & OCCULT
_____BOOK OF TALISMANS, AMULETS & ZODIACAL GEMS _William Pavitt_ — 4.00
_____CONCENTRATION—A Guide to Mental Mastery _Mouni Sadhu_ — 3.00
_____CRITIQUES OF GOD _Edited by Peter Angeles_ — 7.00
_____DREAMS & OMENS REVEALED _Fred Gettings_ — 3.00
_____EXTRA-TERRESTRIAL INTELLIGENCE—The First Encounter — 6.00
_____FORTUNE TELLING WITH CARDS _P. Foli_ — 3.00
_____HANDWRITING ANALYSIS MADE EASY _John Marley_ — 3.00
_____HANDWRITING TELLS _Nadya Olyanova_ — 5.00
_____HOW TO UNDERSTAND YOUR DREAMS _Geoffrey A. Dudley_ — 3.00
_____ILLUSTRATED YOGA _William Zorn_ — 3.00
_____IN DAYS OF GREAT PEACE _Mouni Sadhu_ — 3.00
_____KING SOLOMON'S TEMPLE IN THE MASONIC TRADITION _Alex Horne_ — 5.00
_____LSD—THE AGE OF MIND _Bernard Roseman_ — 2.00
_____MAGICIAN—His training and work _W. E. Butler_ — 3.00
_____MEDITATION _Mouni Sadhu_ — 5.00
_____MODERN NUMEROLOGY _Morris C. Goodman_ — 3.00
_____NUMEROLOGY—ITS FACTS AND SECRETS _Ariel Yvon Taylor_ — 3.00
_____NUMEROLOGY MADE EASY _W. Mykian_ — 3.00
_____PALMISTRY MADE EASY _Fred Gettings_ — 3.00
_____PALMISTRY MADE PRACTICAL _Elizabeth Daniels Squire_ — 3.00
_____PALMISTRY SECRETS REVEALED _Henry Frith_ — 3.00
_____PROPHECY IN OUR TIME _Martin Ebon_ — 2.50
_____PSYCHOLOGY OF HANDWRITING _Nadya Olyanova_ — 3.00
_____SUPERSTITION—Are you superstitious? _Eric Maple_ — 2.00
_____TAROT _Mouni Sadhu_ — 6.00
_____TAROT OF THE BOHEMIANS _Papus_ — 5.00
_____WAYS TO SELF-REALIZATION _Mouni Sadhu_ — 3.00
_____WHAT YOUR HANDWRITING REVEALS _Albert E. Hughes_ — 2.00
_____WITCHCRAFT, MAGIC & OCCULTISM—A Fascinating History _W. B. Crow_ — 5.00
_____WITCHCRAFT—THE SIXTH SENSE _Justine Glass_ — 4.00
_____WORLD OF PSYCHIC RESEARCH _Hereward Carrington_ — 2.00

SELF-HELP & INSPIRATIONAL
_____DAILY POWER FOR JOYFUL LIVING _Dr. Donald Curtis_ — 3.00
_____DYNAMIC THINKING _Melvin Powers_ — 2.00
_____EXUBERANCE—Your Guide to Happiness & Fulfillment _Dr. Paul Kurtz_ — 3.00
_____GREATEST POWER IN THE UNIVERSE _U. S. Andersen_ — 5.00
_____GROW RICH WHILE YOU SLEEP _Ben Sweetland_ — 3.00
_____GROWTH THROUGH REASON _Albert Ellis, Ph.D._ — 4.00
_____GUIDE TO DEVELOPING YOUR POTENTIAL _Herbert A. Otto, Ph.D._ — 3.00
_____GUIDE TO LIVING IN BALANCE _Frank S. Caprio, M.D._ — 2.00
_____HELPING YOURSELF WITH APPLIED PSYCHOLOGY _R. Henderson_ — 2.00
_____HELPING YOURSELF WITH PSYCHIATRY _Frank S. Caprio, M.D._ — 2.00
_____HOW TO ATTRACT GOOD LUCK _A. H. Z. Carr_ — 4.00
_____HOW TO CONTROL YOUR DESTINY _Norvell_ — 3.00
_____HOW TO DEVELOP A WINNING PERSONALITY _Martin Panzer_ — 3.00
_____HOW TO DEVELOP AN EXCEPTIONAL MEMORY _Young & Gibson_ — 4.00
_____HOW TO OVERCOME YOUR FEARS _M. P. Leahy, M.D._ — 3.00
_____HOW YOU CAN HAVE CONFIDENCE AND POWER _Les Giblin_ — 3.00
_____HUMAN PROBLEMS & HOW TO SOLVE THEM _Dr. Donald Curtis_ — 3.00
_____I CAN _Ben Sweetland_ — 4.00
_____I WILL _Ben Sweetland_ — 3.00
_____LEFT-HANDED PEOPLE _Michael Barsley_ — 4.00

____MAGIC IN YOUR MIND *U. S. Andersen*		5.00
____MAGIC OF THINKING BIG *Dr. David J. Schwartz*		3.00
____MAGIC POWER OF YOUR MIND *Walter M. Germain*		4.00
____MENTAL POWER THROUGH SLEEP SUGGESTION *Melvin Powers*		3.00
____NEW GUIDE TO RATIONAL LIVING *Albert Ellis, Ph.D. & R. Harper, Ph.D.*		3.00
____OUR TROUBLED SELVES *Dr. Allan Fromme*		3.00
____PSYCHO-CYBERNETICS *Maxwell Maltz, M.D.*		2.00
____SCIENCE OF MIND IN DAILY LIVING *Dr. Donald Curtis*		3.00
____SECRET OF SECRETS *U. S. Andersen*		4.00
____SECRET POWER OF THE PYRAMIDS *U. S. Andersen*		5.00
____STUTTERING AND WHAT YOU CAN DO ABOUT IT *W. Johnson, Ph.D.*		2.50
____SUCCESS-CYBERNETICS *U. S. Andersen*		4.00
____10 DAYS TO A GREAT NEW LIFE *William E. Edwards*		3.00
____THINK AND GROW RICH *Napoleon Hill*		3.00
____THREE MAGIC WORDS *U. S. Andersen*		5.00
____TREASURY OF COMFORT *edited by Rabbi Sidney Greenberg*		5.00
____TREASURY OF THE ART OF LIVING *Sidney S. Greenberg*		5.00
____YOU ARE NOT THE TARGET *Laura Huxley*		4.00
____YOUR SUBCONSCIOUS POWER *Charles M. Simmons*		4.00
____YOUR THOUGHTS CAN CHANGE YOUR LIFE *Dr. Donald Curtis*		4.00

SPORTS

____BICYCLING FOR FUN AND GOOD HEALTH *Kenneth E. Luther*		2.00
____BILLIARDS—Pocket • Carom • Three Cushion *Clive Cottingham, Jr.*		3.00
____CAMPING-OUT 101 Ideas & Activities *Bruno Knobel*		2.00
____COMPLETE GUIDE TO FISHING *Vlad Evanoff*		2.00
____HOW TO IMPROVE YOUR RACQUETBALL *Lubarsky, Kaufman, & Scagnetti*		3.00
____HOW TO WIN AT POCKET BILLIARDS *Edward D. Knuchell*		4.00
____JOY OF WALKING *Jack Scagnetti*		3.00
____LEARNING & TEACHING SOCCER SKILLS *Eric Worthington*		3.00
____MOTORCYCLING FOR BEGINNERS *I. G. Edmonds*		3.00
____RACQUETBALL FOR WOMEN *Toni Hudson, Jack Scagnetti & Vince Rondone*		3.00
____RACQUETBALL MADE EASY *Steve Lubarsky, Rod Delson & Jack Scagnetti*		3.00
____SECRET OF BOWLING STRIKES *Dawson Taylor*		3.00
____SECRET OF PERFECT PUTTING *Horton Smith & Dawson Taylor*		3.00
____SOCCER—The game & how to play it *Gary Rosenthal*		3.00
____STARTING SOCCER *Edward F. Dolan, Jr.*		3.00
____TABLE TENNIS MADE EASY *Johnny Leach*		2.00

TENNIS LOVERS' LIBRARY

____BEGINNER'S GUIDE TO WINNING TENNIS *Helen Hull Jacobs*		2.00
____HOW TO BEAT BETTER TENNIS PLAYERS *Loring Fiske*		4.00
____HOW TO IMPROVE YOUR TENNIS—Style, Strategy & Analysis *C. Wilson*		2.00
____INSIDE TENNIS—Techniques of Winning *Jim Leighton*		3.00
____PLAY TENNIS WITH ROSEWALL *Ken Rosewall*		2.00
____PSYCH YOURSELF TO BETTER TENNIS *Dr. Walter A. Luszki*		2.00
____SUCCESSFUL TENNIS *Neale Fraser*		2.00
____TENNIS FOR BEGINNERS *Dr. H. A. Murray*		2.00
____TENNIS MADE EASY *Joel Brecheen*		2.00
____WEEKEND TENNIS—How to have fun & win at the same time *Bill Talbert*		3.00
____WINNING WITH PERCENTAGE TENNIS—Smart Strategy *Jack Lowe*		2.00

WILSHIRE PET LIBRARY

____DOG OBEDIENCE TRAINING *Gust Kessopulos*		4.00
____DOG TRAINING MADE EASY & FUN *John W. Kellogg*		3.00
____HOW TO BRING UP YOUR PET DOG *Kurt Unkelbach*		2.00
____HOW TO RAISE & TRAIN YOUR PUPPY *Jeff Griffen*		2.00
____PIGEONS: HOW TO RAISE & TRAIN THEM *William H. Allen, Jr.*		2.00

The books listed above can be obtained from your book dealer or directly from Melvin Powers. When ordering, please remit 50¢ per book postage & handling. Send for our free illustrated catalog of self-improvement books.

Melvin Powers

12015 Sherman Road, No. Hollywood, California 91605

WILSHIRE HORSE LOVERS' LIBRARY

____AMATEUR HORSE BREEDER *A. C. Leighton Hardman*	3.00
____AMERICAN QUARTER HORSE IN PICTURES *Margaret Cabell Self*	3.00
____APPALOOSA HORSE *Donna & Bill Richardson*	3.00
____ARABIAN HORSE *Reginald S. Summerhays*	2.00
____ART OF WESTERN RIDING *Suzanne Norton Jones*	3.00
____AT THE HORSE SHOW *Margaret Cabell Self*	3.00
____BACK-YARD FOAL *Peggy Jett Pittinger*	3.00
____BACK-YARD HORSE *Peggy Jett Pittinger*	3.00
____BASIC DRESSAGE *Jean Froissard*	2.00
____BEGINNER'S GUIDE TO HORSEBACK RIDING *Sheila Wall*	2.00
____BEGINNER'S GUIDE TO THE WESTERN HORSE *Natlee Kenoyer*	2.00
____BITS—THEIR HISTORY, USE AND MISUSE *Louis Taylor*	3.00
____BREAKING & TRAINING THE DRIVING HORSE *Doris Ganton*	2.00
____BREAKING YOUR HORSE'S BAD HABITS *W. Dayton Sumner*	3.00
____CAVALRY MANUAL OF HORSEMANSHIP *Gordon Wright*	3.00
____COMPLETE TRAINING OF HORSE AND RIDER *Colonel Alois Podhajsky*	4.00
____DISORDERS OF THE HORSE & WHAT TO DO ABOUT THEM *E. Hanauer*	3.00
____DOG TRAINING MADE EASY & FUN *John W. Kellogg*	3.00
____DRESSAGE—A Study of the Finer Points in Riding *Henry Wynmalen*	4.00
____DRIVING HORSES *Sallie Walrond*	3.00
____ENDURANCE RIDING *Ann Hyland*	2.00
____EQUITATION *Jean Froissard*	4.00
____FIRST AID FOR HORSES *Dr. Charles H. Denning, Jr.*	2.00
____FUN OF RAISING A COLT *Rubye & Frank Griffith*	3.00
____FUN ON HORSEBACK *Margaret Cabell Self*	4.00
____GYMKHANA GAMES *Natlee Kenoyer*	2.00
____HORSE DISEASES—Causes, Symptoms & Treatment *Dr. H. G. Belschner*	4.00
____HORSE OWNER'S CONCISE GUIDE *Elsie V. Hanauer*	2.00
____HORSE SELECTION & CARE FOR BEGINNERS *George H. Conn*	4.00
____HORSE SENSE—A complete guide to riding and care *Alan Deacon*	4.00
____HORSEBACK RIDING FOR BEGINNERS *Louis Taylor*	4.00
____HORSEBACK RIDING MADE EASY & FUN *Sue Henderson Coen*	4.00
____HORSES—Their Selection, Care & Handling *Margaret Cabell Self*	3.00
____HOW TO BUY A BETTER HORSE & SELL THE HORSE YOU OWN	3.00
____HOW TO ENJOY YOUR QUARTER HORSE *Williard H. Porter*	3.00
____HUNTER IN PICTURES *Margaret Cabell Self*	2.00
____ILLUSTRATED BOOK OF THE HORSE *S. Sidney* (8½" x 11")	10.00
____ILLUSTRATED HORSE MANAGEMENT—400 Illustrations *Dr. E. Mayhew*	6.00
____ILLUSTRATED HORSE TRAINING *Captain M. H. Hayes*	5.00
____ILLUSTRATED HORSEBACK RIDING FOR BEGINNERS *Jeanne Mellin*	2.00
____JUMPING—Learning & Teaching *Jean Froissard*	3.00
____KNOW ALL ABOUT HORSES *Harry Disston*	3.00
____LAME HORSE—Causes, Symptoms & Treatment *Dr. James R. Rooney*	4.00
____LAW & YOUR HORSE *Edward H. Greene*	5.00
____LIPIZZANERS & THE SPANISH RIDING SCHOOL *W. Reuter* (4¼" x 6")	2.50
____MANUAL OF HORSEMANSHIP *Harold Black*	5.00
____MORGAN HORSE IN PICTURES *Margaret Cabell Self*	2.00
____MOVIE HORSES—The Fascinating Techniques of Training *Anthony Amaral*	2.00
____POLICE HORSES *Judith Campbell*	2.00
____PRACTICAL GUIDE TO HORSESHOEING	3.00
____PRACTICAL GUIDE TO OWNING YOUR OWN HORSE *Steven D. Price*	2.00
____PRACTICAL HORSE PSYCHOLOGY *Moyra Williams*	3.00
____PROBLEM HORSES Guide for Curing Serious Behavior Habits *Summerhays*	3.00
____REINSMAN OF THE WEST—BRIDLES & BITS *Ed Connell*	4.00
____RESCHOOLING THE THOROUGHBRED *Peggy Jett Pittenger*	3.00
____RIDE WESTERN *Louis Taylor*	3.00
____SCHOOLING YOUR YOUNG HORSE *George Wheatley*	2.00
____STABLE MANAGEMENT FOR THE OWNER-GROOM *George Wheatley*	4.00
____STALLION MANAGEMENT—A Guide for Stud Owners *A. C. Hardman*	3.00
____TEACHING YOUR HORSE TO JUMP *W. J. Froud*	2.00
____TRAIL HORSES & TRAIL RIDING *Anne & Perry Westbrook*	2.00
____TRAINING YOUR HORSE TO SHOW *Neale Haley*	4.00
____TREATING COMMON DISEASES OF YOUR HORSE *Dr. George H. Conn*	3.00
____TREATING HORSE AILMENTS *G. W. Serth*	2.00
____WESTERN HORSEBACK RIDING *Glen Balch*	3.00
____YOU AND YOUR PONY *Pepper Mainwaring Healey* (8½" x 11")	6.00
____YOUR FIRST HORSE *George C. Saunders, M.D.*	3.00
____YOUR PONY BOOK *Hermann Wiederhold*	2.00
____YOUR WESTERN HORSE *Nelson C. Nye*	2.00

*The books listed above can be obtained from your book dealer or directly from
Melvin Powers. When ordering, please remit 50¢ per book postage & handling.
Send for our free illustrated catalog of self-improvement books.*

Melvin Powers

12015 Sherman Road, No. Hollywood, California 91605